You Can Draw

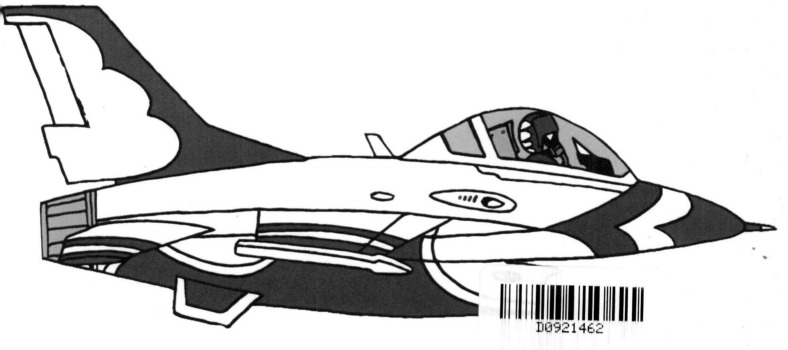

Planes

SALARIYA

Published in Great Britain in MMXII by
Book House, an imprint of
The Salariya Book Company Ltd
25 Marlborough Place, Brighton BN1 1UB

1 3 5 7 9 8 6 4 2

Please visit our websites at **www.salariya.com** or
www.book-house.co.uk for **free** electronic versions of:
You Wouldn't Want to Be an Egyptian Mummy!
You Wouldn't Want to Be a Roman Gladiator!
You Wouldn't Want to be a Polar Explorer!
**You Wouldn't Want to Sail on a 19th-Century
 Whaling Ship!**

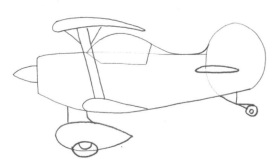

Author: Mark Bergin was born in Hastings in 1961. He
studied at Eastbourne College of Art and has specialised
in historical reconstructions as well as aviation and
maritime subjects since 1983. He lives in Bexhill-on-
Sea with his wife and three children.

Editor: Rob Walker

PB ISBN: 978-1-908759-53-5

A CIP catalogue record for this book is available from
the British Library.

Printed and bound in China.
Printed on paper from sustainable sources.

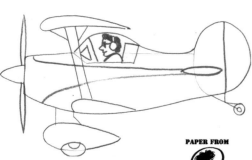

Visit our **new** online shop at
shop.salariya.com
for great offers, gift ideas, all our new releases

and free postage and packaging.

**PAPER FROM
SUSTAINABLE
FORESTS**

By Mark Bergin

Planes

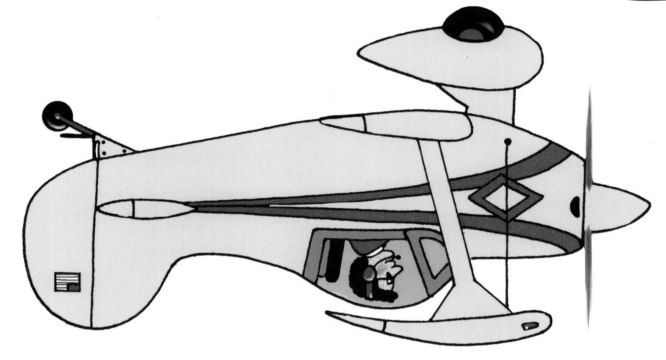

You Can Draw

Contents

Introduction

Learning to draw is fun. In this book a finished drawing will be broken up into stages as a guide to completing your own drawing. However, this is only the beginning. The more you practise, the better you will get. Have fun coming up with cool designs, adding more incredible details and using new materials to achieve different effects!

This example shows how the drawing is separated into stages. Each stage shows the part you need to draw next in red and the previously drawn parts in black.

1

2

3

4

5

With practice you too will be able to draw planes just like these examples shown here.

Materials

There are many different art materials available which you can use to draw and colour in your planes. Try out each one for new and exciting results. The more you practise with them, the better your drawing skills will get!

Use a pencil when drawing the shape of your plane. Any mistakes you make can easily be erased, as can any construction lines that are left over at the end of your drawing.

An eraser can be used to get rid of pencil mistakes. It can also be used to create highlights on pencil drawings.

You can go over your finished pencil lines with pen to make the lines stand out more. But remember using a pen means you can't erase any mistakes!

Coloured pencils come in a huge range of colours and can be layered over each other for new and exciting effects.

Pastels can be smudged and blended together to give you all sorts of types of tone.

Felt tip pens can give you vibrant colours when colouring your drawing in. But remember that they are hard to layer and you can't make any mistakes!

Inspiration

There are many types of planes made throughout the world. You can use any of them for the inspiration for your cartoon-style drawing. Photos, magazines or books can give you new ideas and new designs to try.

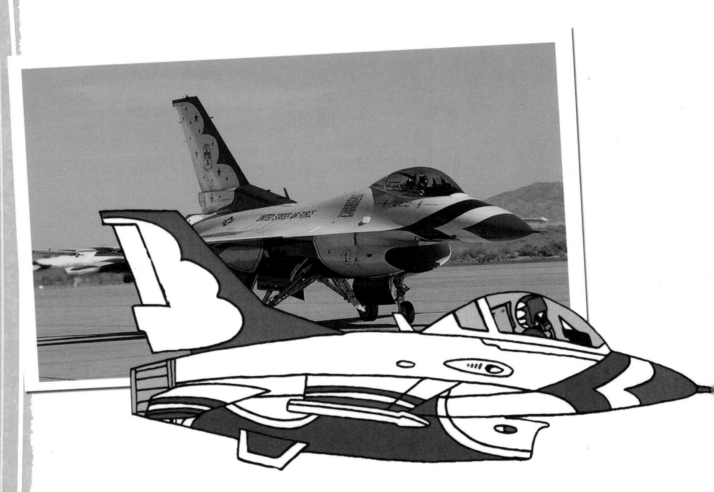

When turning your plane into a cartoon-style, two-dimensional drawing, make note of the key elements you want to keep and the general shape of the plane.

Use new colours and designs to make your plane look the way you want it to. It's your drawing after all.

One way to make your plane look cool is to make it a lot shorter and exaggerate key features.

Learjet 28

Learjets are small passenger planes. They only have enough room for two pilots and eight passengers.

Draw a rectangle for the fuselage and then draw in the shape of the nose and tail.

Add the fin (vertical stabiliser) and the wing.

Add the extra details to both the fin and wing. Add the extra shape to the fuselage.

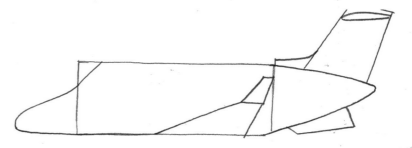

Draw in the cockpit window. Add the jet engine and the wing and fin flaps.

Add the pilot in the cockpit window. Then add lines across the fuselage, a door and three windows.

Finish your Learjet by colouring in the different sections. Add any remaining details.

Bleriot XI

The Bleriot XI was the first heavier-than-air aircraft to cross the English Channel. The feat was accomplished on 25 July, 1909.

Draw a long rectangle for the fuselage. Add the tail fin.

Add circles for wheels and draw in the lines to connect the front wheel to the fuselage.

Separate the sections of the fuselage with lines and add the wing and the horizontal stabiliser.

Draw in the propeller and add more of the fuselage's construction. Connect the rear wheel to the fuselage.

Draw in the engine parts and add extra detail to the wing. Draw in the pilot and complete the remaining fuselage detail.

Add the final details to the fuselage and then complete your drawing by colouring it in.

F-16

The F-16 Fighting Falcon is an incredibly nimble and fast aircraft. In this drawing its paintwork shows it to be part of the USAF Thunderbirds display team.

Draw in the long fuselage, pointed at one end. Add the large tail fin.

Draw a curved line for the cockpit window. Add the large bottom section under the fuselage.

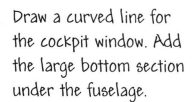

Add the shapes for the wing and horizontal stabilisers.

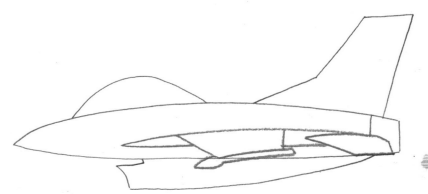

Add detail to the cockpit window. Draw in the flaps on the tail fin.

Draw in the pilot. Draw the paintwork design onto the plane. Finally, add the jet engine exhaust.

Finish off your F-16 by colouring each section of the design and adding any remaining detail.

Gee Bee

The Gee Bee was a fast, trophy-winning racing plane, built in 1932. 'Gee Bee' (G.B.) stands for the aircraft's manufacturers, Granville Brothers.

Draw a rectangle for the fuselage and add the tail section.

Add the small cockpit window attached to the tail section.

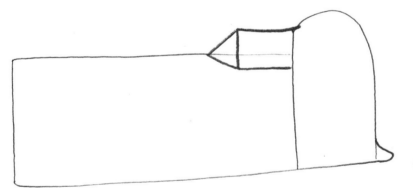

Draw in the propeller hub, the wing and horizontal stabiliser.

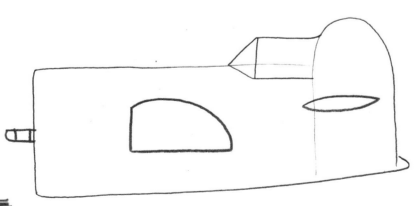

Draw in the landing gear attached to the wing and the bottom of the tail section.

Add the propellers to the hub. Divide the plane sections and add wing and tail flaps. Finally, draw in the pilot.

Finish off the drawing by adding a cool design and colouring it in!

Mustang

The P-51 Mustang was designed as a military plane, but it also set many distance and speed records in its time.

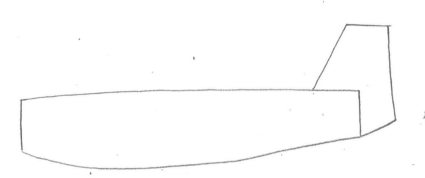

Draw the shape of the fuselage and add the tail fin shape.

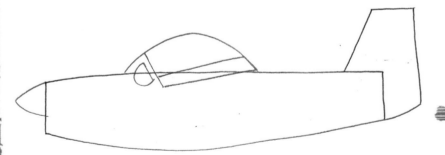

Add the propeller hub and draw in the domed cockpit window.

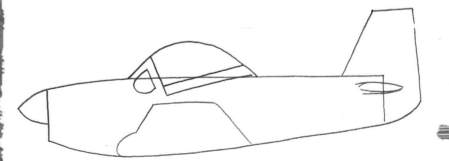

Draw in the wing and the horizontal stabiliser.

Add the propellers, the bottom section and a flap in the tail fin.

Draw in a row of engine exhausts and divide the engine section. Add the pilot and wing detail.

Complete the P-51 Mustang by dividing the fuselage sections, adding a design and colouring it in.

Glider

A glider has no engine and rides air currents to remain in flight.

Draw an oval for the cockpit and a line for the tail.

Add the glider's window and finish the shape of the tail.

Add a wing.

Draw a fin
(a vertical stabiliser)
onto the tail.

Add more detail to the
plane, a pilot and flaps
for the wings.

Finish your drawing by adding new details and
colouring in the plane's sections.

Bell X-1

The Bell X-1 was an experimental supersonic aircraft built in 1945. It could reach speeds of 1,000 mph (1,609 kph).

Draw the long, pointed fuselage.

Add the tail fin and a line running above the fuselage.

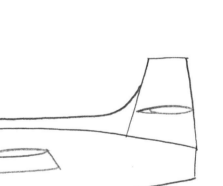

Draw in the wing and horizontal stabiliser.

Draw in the nose
spike, cockpit window
and other details.

Add the pilot and the frame
of the cockpit window. Add
the USAF logo.

Finish the drawing by colouring in the different sections.

Seaplane

Seaplanes are capable of taking off and landing on water. This one has pontoons instead of wheels to keep it afloat.

Draw the shape of the fuselage. Add the tail fin.

Draw in the wing and add the propeller hub. Place the cockpit.

Draw in the pontoons attached to the underside of the plane.

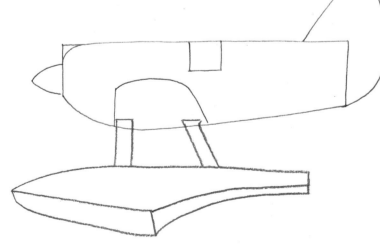

Add the propellers to the hub. Divide the main fuselage to show the engine and tail sections.

Draw in the engine details, and add a pilot.

Finish the details of the plane, adding shading and your own design.

Pitts Special

The Pitts Special is a light aircraft designed for incredible aerial acrobatics.

First draw in the basic fuselage shape, adding a tail.

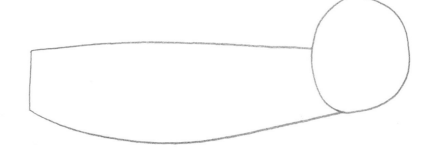

Add the propeller and the cockpit window.

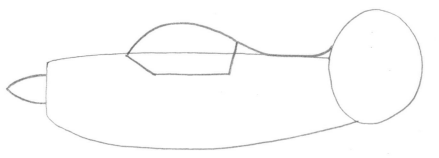

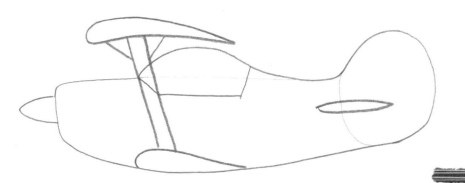

Draw in the wings, including the structure joints.

Add the landing gear and tail details.

Draw in the propeller, and add a pilot and fuselage design.

Colour in your drawing, adding a striking design and other details.

29

More Views

For another drawing challenge try drawing your plane from the front or rear! Practising different views will help you get better at drawing.

Learjet

Start with a circle for the fuselage. Add the wings.

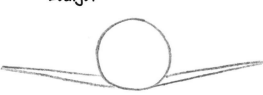

Add the tail fin, with the horizontal stabilisers sticking out.

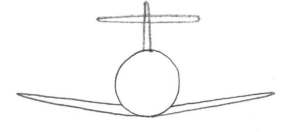

Add two circles for engines and add a circle for the nose.

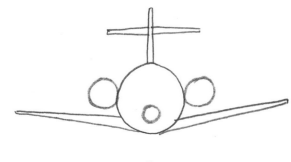

Draw in the wing tips, the dark parts of the engines and cockpit window.

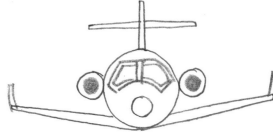

Start with a circle for the fuselage. Add the wings.

Add a dark circle for the jet exhaust and draw in the tail fin and horizontal stabilisers.

Draw in the cockpit window and add the shape of the bottom section underneath the fuselage.

Complete the final details of the wings, cockpit window and exhaust. Add two small fins to the back of the bottom section.

Glossary

aerial acrobatics (also known as 'aerobatics') The impressive mid-air stunts performed by a display team.

air currents Naturally-occurring gusts of wind.

cockpit The part of a plane in which the pilot sits.

construction lines Guidelines used in the early stages of a drawing. They are usually erased later.

display team A team of pilots who perform stunts together in planes.

fuselage The main body of a plane.

jet engine A very powerful engine which enables planes to fly very fast.

landing gear Wheels at the bottom of a plane that help it to land smoothly.

pontoon A platform that floats on water.

propeller A fast-spinning object that helps some planes to fly.

stabiliser A small horizontal or vertical wing which helps to balance the plane out.

supersonic Faster than the speed of sound.

Index